HEDGEHUGS

Andrews McMeel
PUBLISHING®

HEDGEHUGS

Andrews McMeel Publishing
a division of Andrews McMeel Universal
1130 Walnut Street, Kansas City, Missouri 64106

www.andrewsmcmeel.com

First published in 2020 by Summersdale Publishers Ltd.
Part of Octopus Publishing Group Limited
Carmelite House
50 Victoria Embankment
London EC4Y 0DZ
United Kingdom

20 21 22 23 24 SHO 10 9 8 7 6 5 4 3 2 1

ISBN: 978-1-5248-6021-9

Library of Congress Control Number: 2019955588

Editor: Kevin Kotur
Art Director: Diane Marsh
Production Manager: Carol Coe
Production Editor: Elizabeth A. Garcia

ATTENTION: SCHOOLS AND BUSINESSES
Andrews McMeel books are available at quantity discounts with bulk purchase for educational, business, or sales promotional use. For information, please e-mail the Andrews McMeel Publishing Special Sales Department: specialsales@amuniversal.com.

INTRODUCTION

Isn't it heartwarming when you see a video of a little hedgehog roaming around outside? These gorgeous creatures, with their tiny button noses and cuter-than-cute ears, will brighten up the gloomiest days. Not only are they pretty little things, but they are fascinating to watch, too. Gentle and shy, yet resolutely determined, hedgehogs love to explore their surroundings and are fantastic foragers.

If you love hedgehogs, you'll love this book, which showcases some of the most adorable hedgehogs ever. Enjoy!

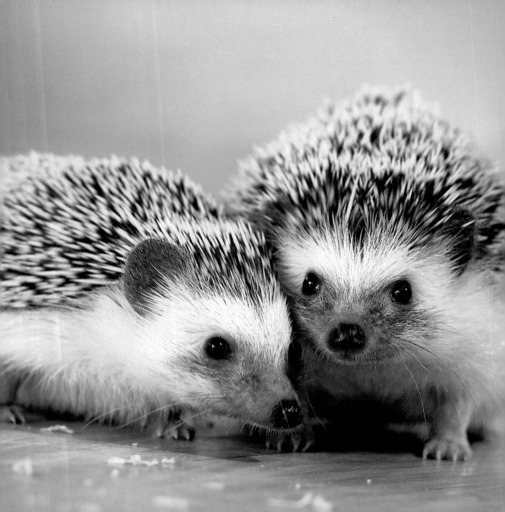

WHEN YOU NEED
A LITTLE LOVE,
♥ GIVE A LITTLE ♥

HEDGEHUG

A HUG IS THE PERFECT GIFT—
ONE SIZE FITS ALL, AND NOBODY
MINDS IF YOU EXCHANGE IT.

Ivern Ball

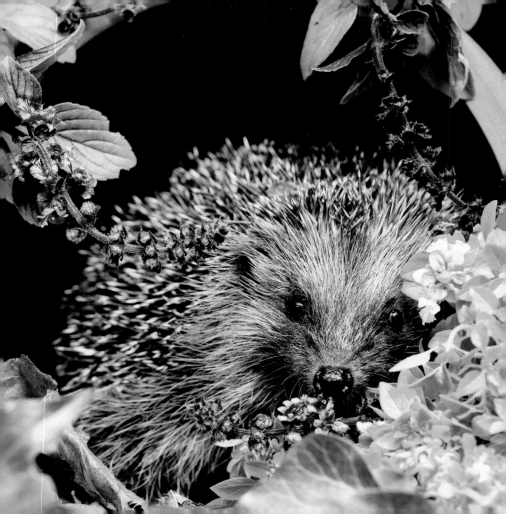

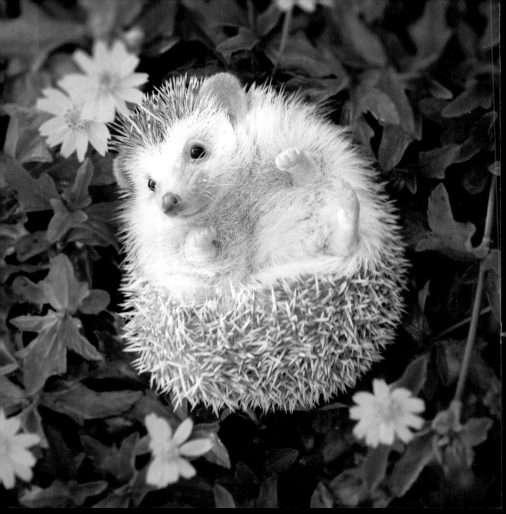

IF YOU'RE HOGGY AND
YOU KNOW IT, CLAP

YOUR HANDS

HAPPINESS IS AN UNEXPECTED HUG.

Anonymous

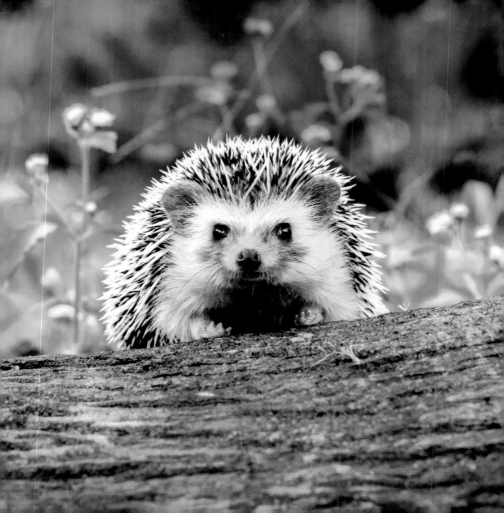

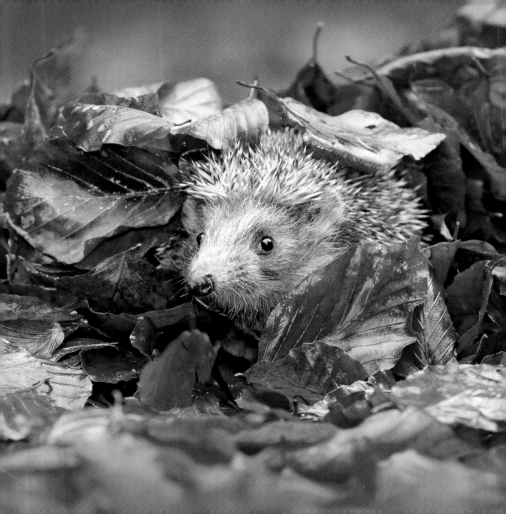

YOU'RE A

TOP HOG

WHEN THE RIGHT PERSON HUGS YOU,
IT'S LIKE MEDICINE. I'M SO GRATEFUL
FOR THOSE FEW PEOPLE IN MY LIFE
WHO ARE GOOD FOR MY SOUL.

Steve Maraboli

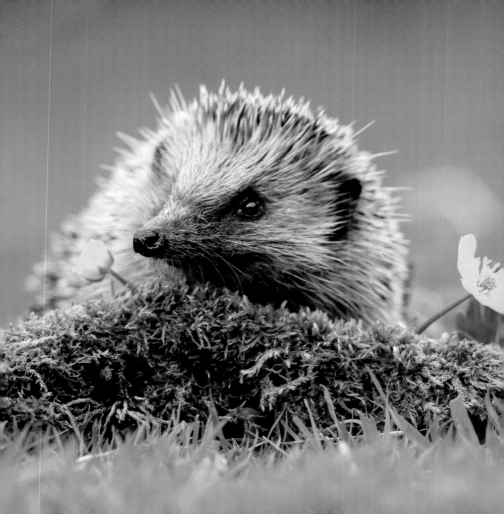

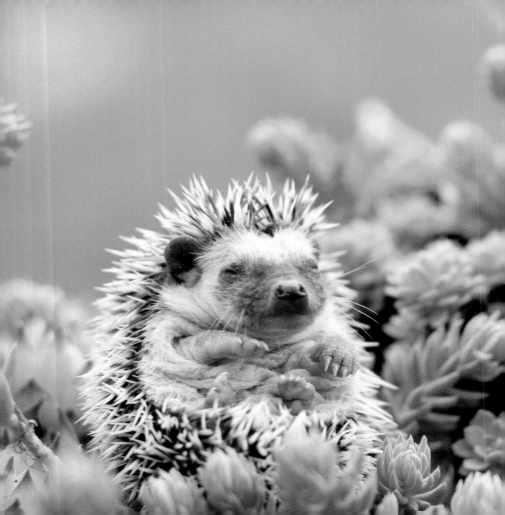

SO SQUISHY

 AND

SMOL

HUGGING: THE TRUEST FORM OF GIVING AND RECEIVING.

Carol CC Miller

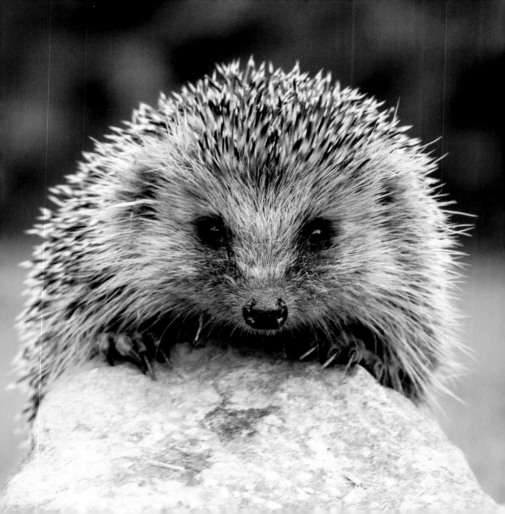

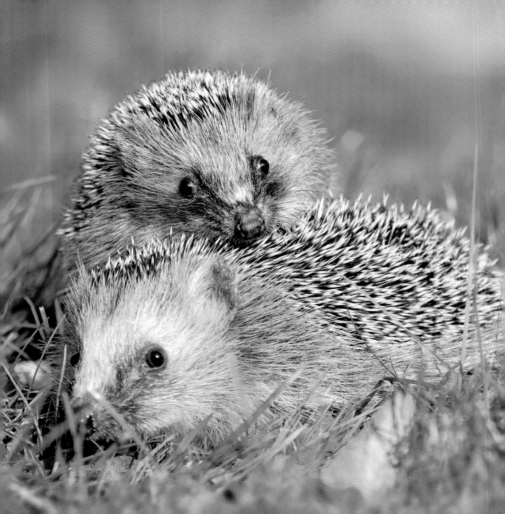

YOU'RE SO

HOGGABLE

THEY INVENTED HUGS TO LET
PEOPLE KNOW YOU LOVE THEM
WITHOUT SAYING ANYTHING.

Bil Keane

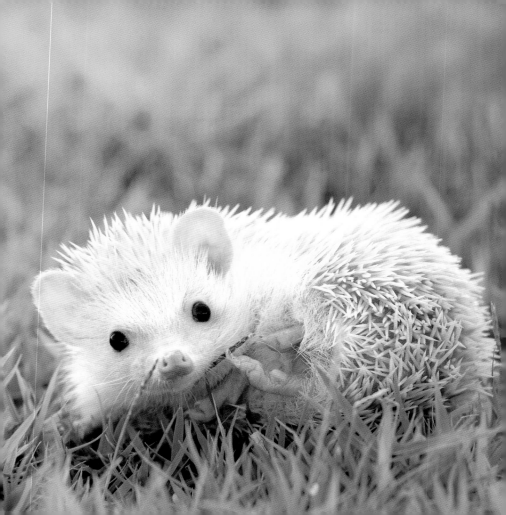

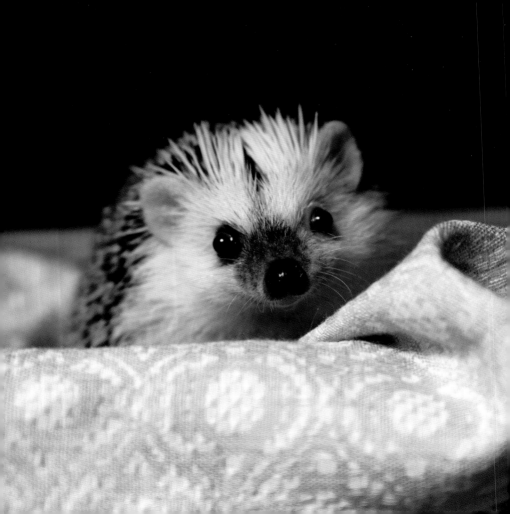

♥ LIFE IS ♥

SWEET

AS THE NIGHTS GET COLDER, THE HUGS GET WARMER.

Anthony T. Hincks

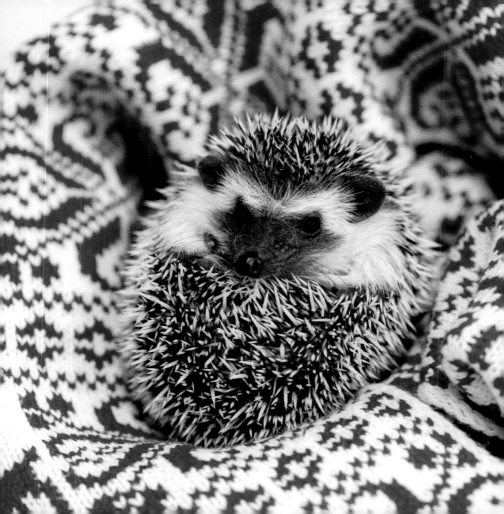

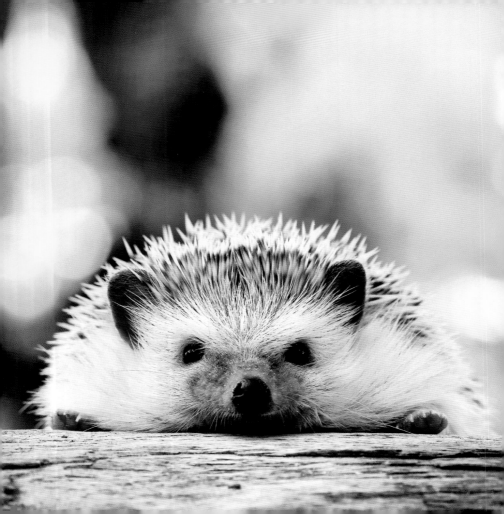

EVERY HOG HAS

ITS DAY

A HUG MAKES YOU FEEL GOOD ALL DAY.

Kathleen Keating

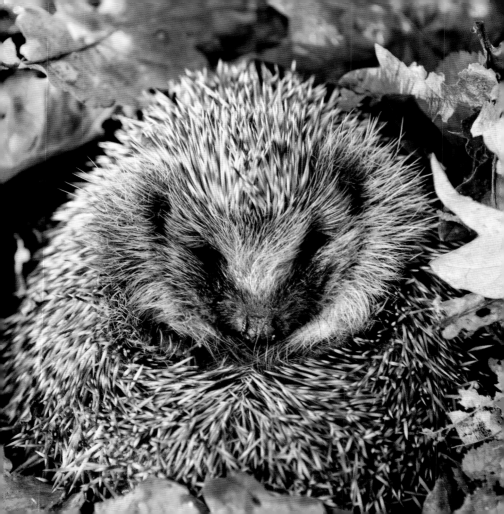

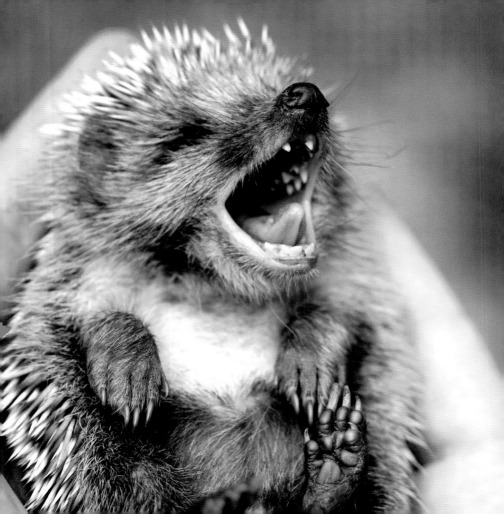

HOG

♥ TIRED ♥

RECYCLE KISSES, HUGS, AND SMILES.
THEY NEVER GO OUT OF STYLE,
AND EVERYBODY NEEDS ONE.

Crystal DeLarm Clymer

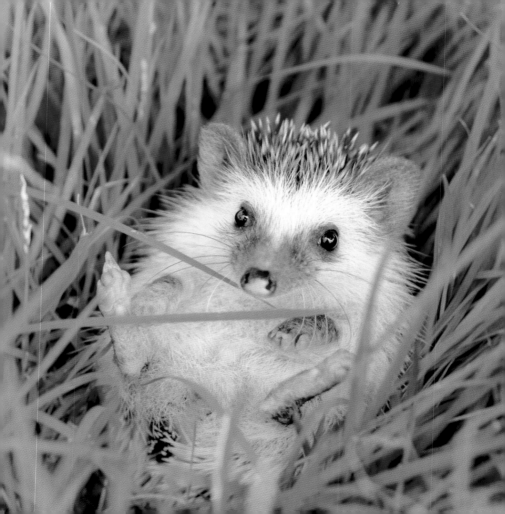

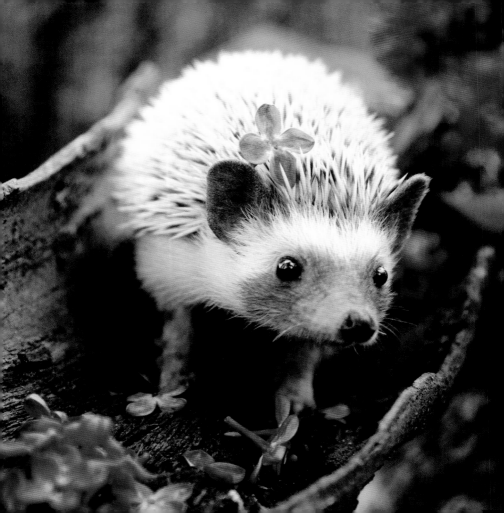

HOT
DIGGITY
HOG

YOU CAN'T WRAP LOVE IN A BOX, BUT YOU CAN WRAP A PERSON IN A HUG.

Anonymous

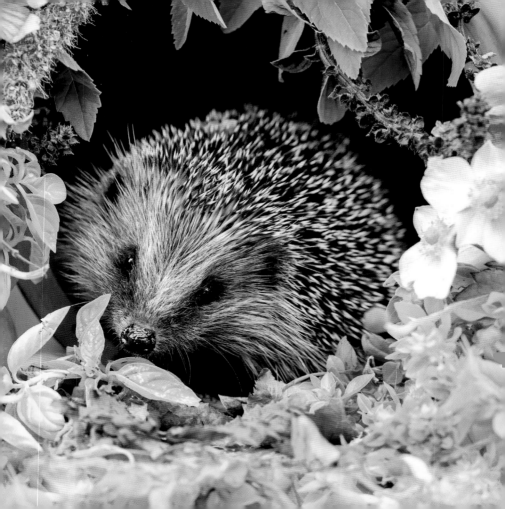

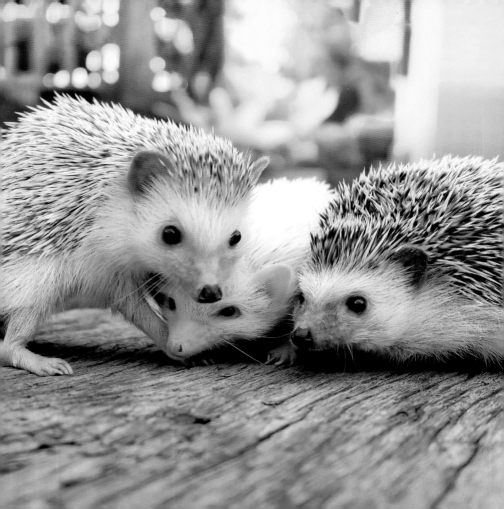

♥ WHO LET THE ♥

HOGS OUT?

THE LOVE WE GIVE AWAY IS THE ONLY LOVE WE KEEP.

Elbert Hubbard

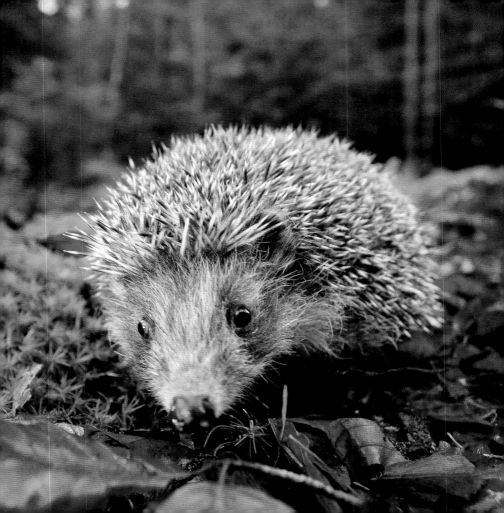

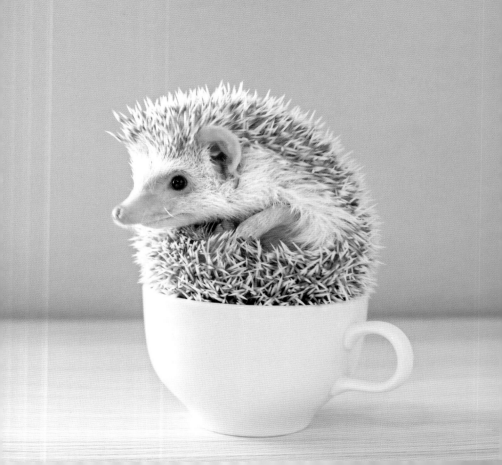

IF I FITS,

I SITS

LOVE IS A CIRCULAR EMOTION THAT SURROUNDS YOU, LIKE A HUG.

Jarod Kintz

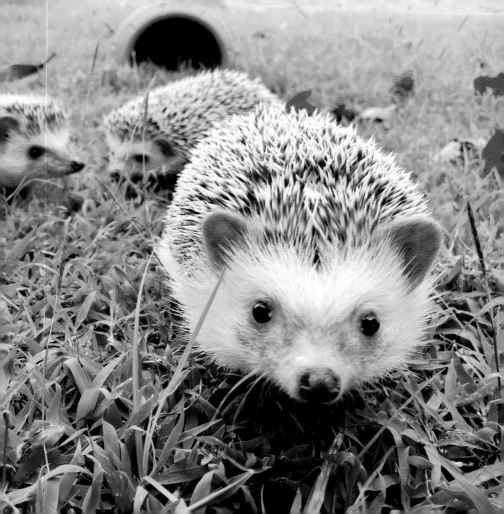

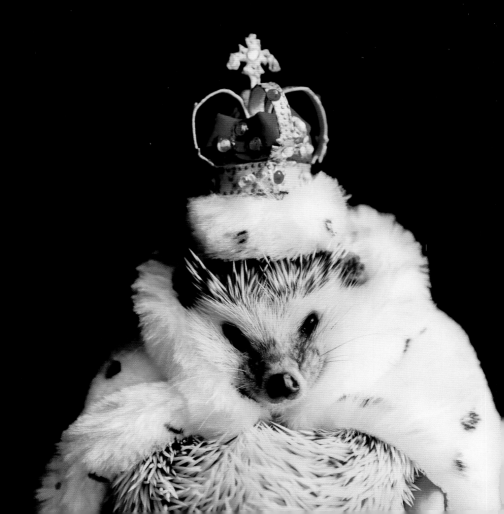

VIH
(VERY IMPORTANT HOG)

LOVE IS THE OIL THAT EASES
FRICTION, THE CEMENT THAT
BINDS CLOSER TOGETHER, AND THE
MUSIC THAT BRINGS HARMONY.

Eva Burrows

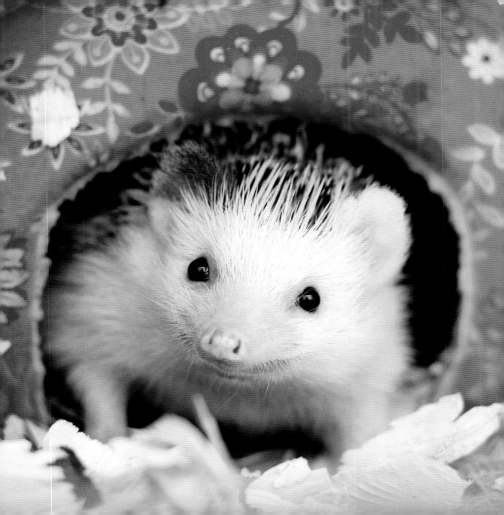

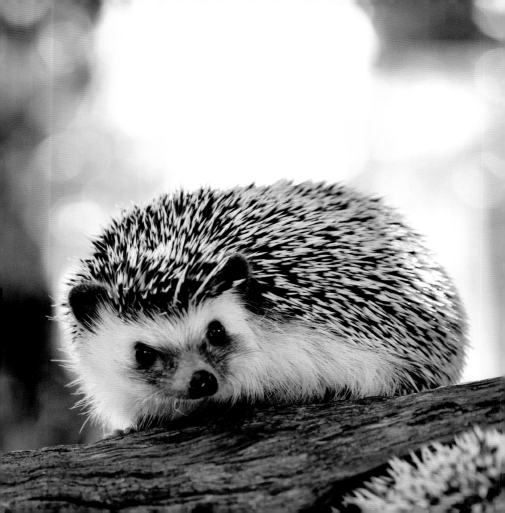

LIVING

♥ ON THE ♥

HEDGE

A HUG OVERCOMES ALL BOUNDARIES.
IT SPEAKS WORDS WITHIN THE
MIND THAT CANNOT BE SPOKEN.

Anonymous

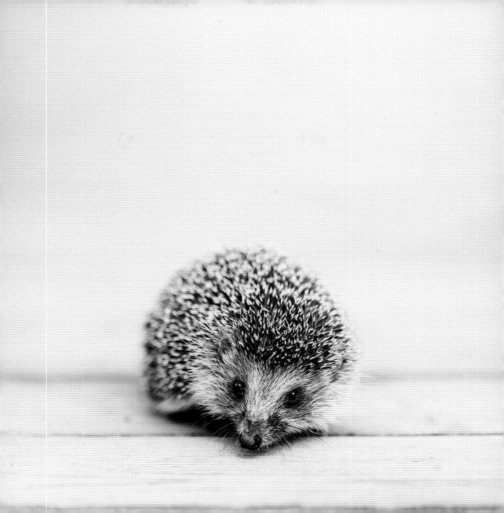

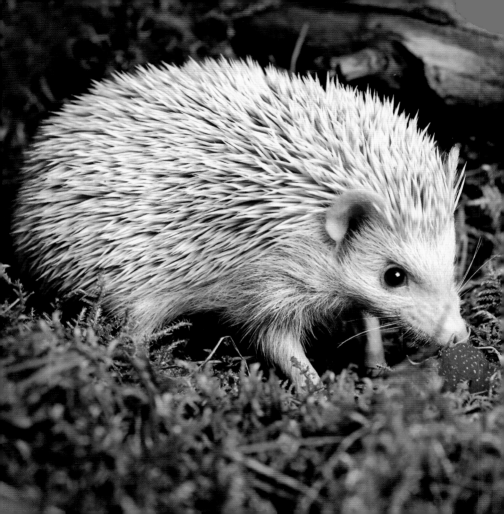

A HOG IS
♥ A MAN'S ♥

BEST FRIEND

LAUGHING TOGETHER IS AS
CLOSE AS YOU CAN GET TO A
HUG WITHOUT TOUCHING.

Gina Barreca

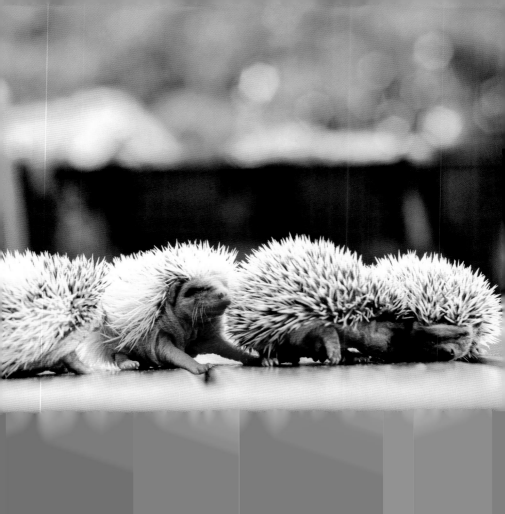

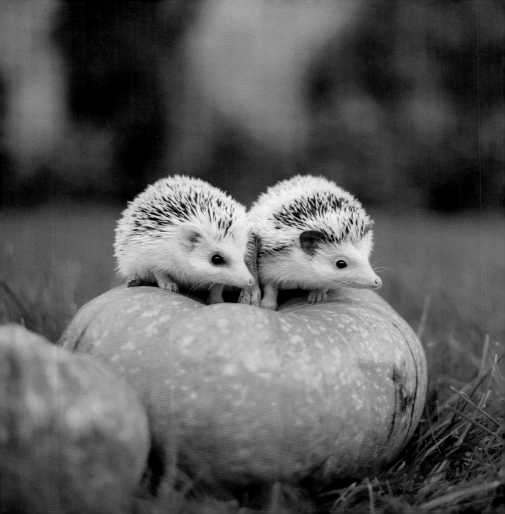

THE DOG DAYS ARE OVER;
♥ THE HOG DAYS ARE ♥

HERE TO STAY

WE NEED FOUR HUGS A DAY FOR SURVIVAL. WE NEED EIGHT HUGS A DAY FOR MAINTENANCE. WE NEED TWELVE HUGS A DAY FOR GROWTH.

Virginia Satir

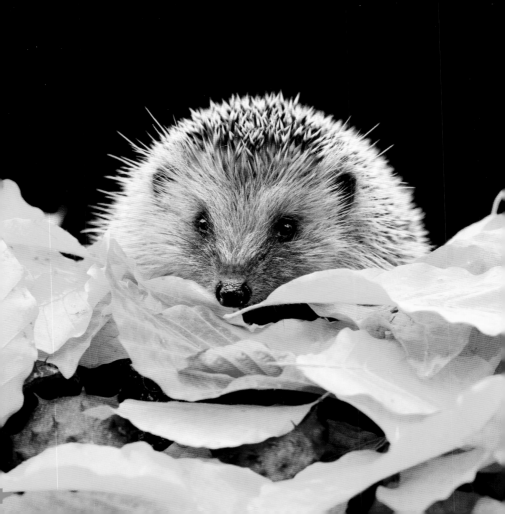

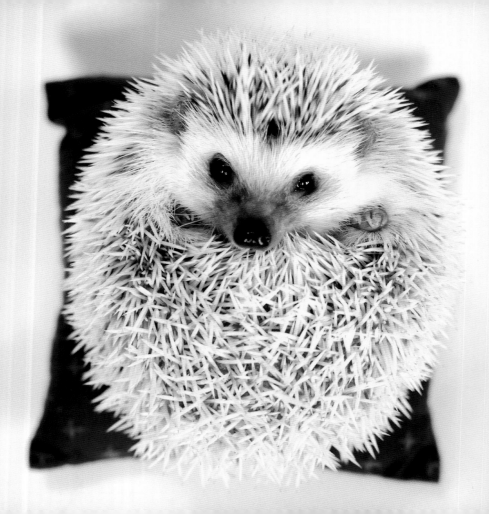

♥ LOOKING ♥

SHARP

NUPTIAL LOVE MAKETH MANKIND; FRIENDLY LOVE PERFECTETH IT.

Francis Bacon

♥ HAIR OF ♥

THE HOG

A HUG IS LIKE A BOOMERANG—YOU GET IT BACK RIGHT AWAY.

Bil Keane

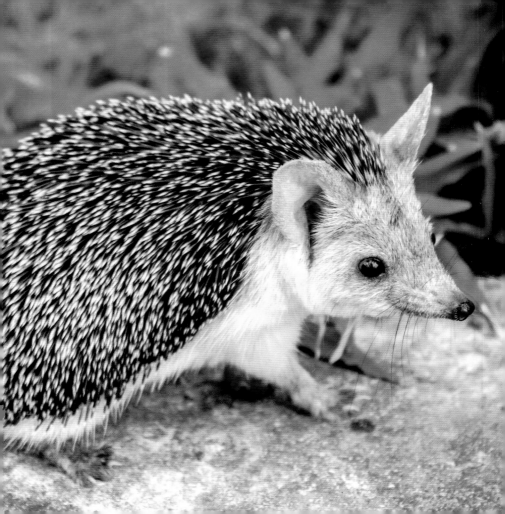

IS IT A BAT?
IS IT A HOG?
♥ NO, IT'S ♥

BAT-HOG!

A HUG IS A HANDSHAKE FROM THE HEART.

Anonymous

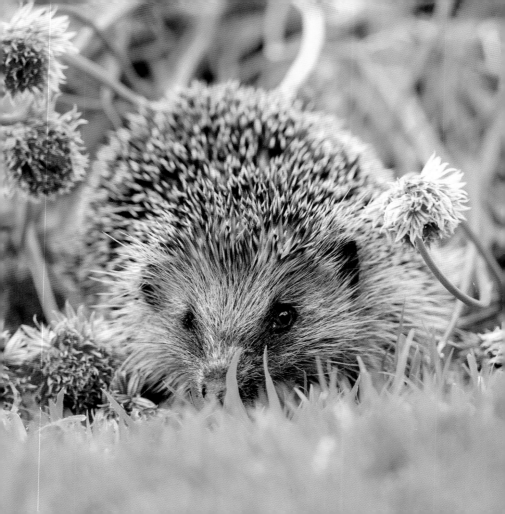

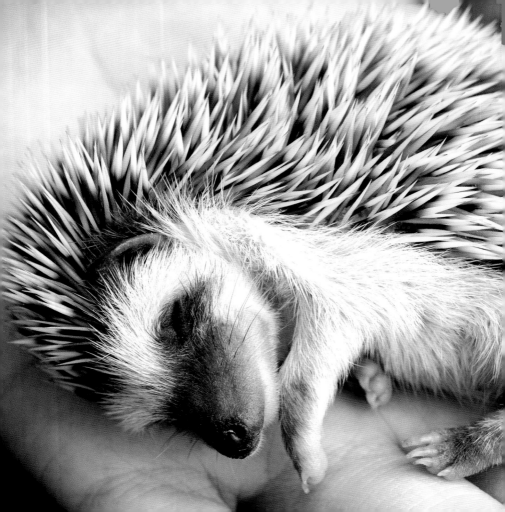

ALL YOU NEED
IS LOVE . . . AND
A BABY HEDGEHOG
♥ ASLEEP IN ♥

YOUR HAND

LOVE . . . IT ENCOMPASSES EVERY
BEING, SLOWLY EXPANDING TO
EMBRACE ALL THAT EVER WILL BE.

Kahlil Gibran

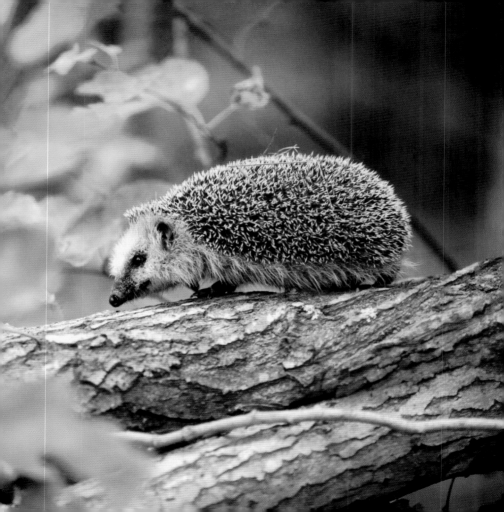

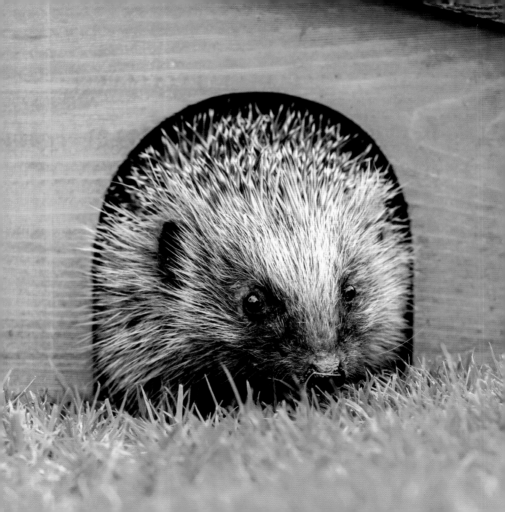

AS SNUG

♥ AS A HOG ♥

IN A HUT

I HAVE LEARNED THAT THERE IS MORE POWER IN A GOOD STRONG HUG THAN IN A THOUSAND MEANINGFUL WORDS.

Ann Hood

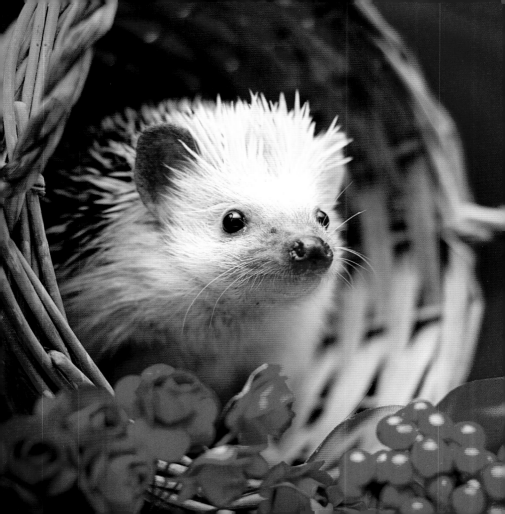

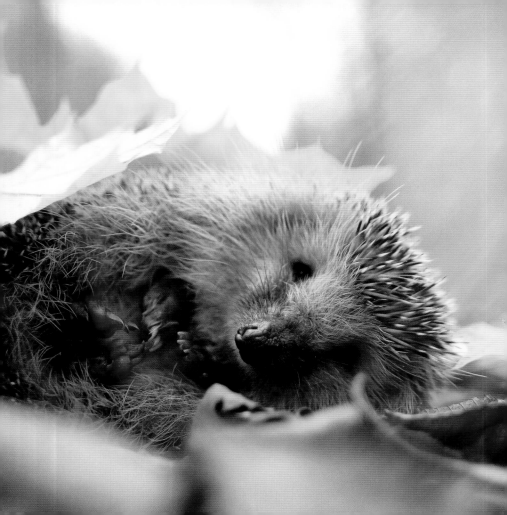

♥ Let sleeping ♥

HOGS LIE

HUGS CAN DO GREAT AMOUNTS OF GOOD.

Diana, Princess of Wales

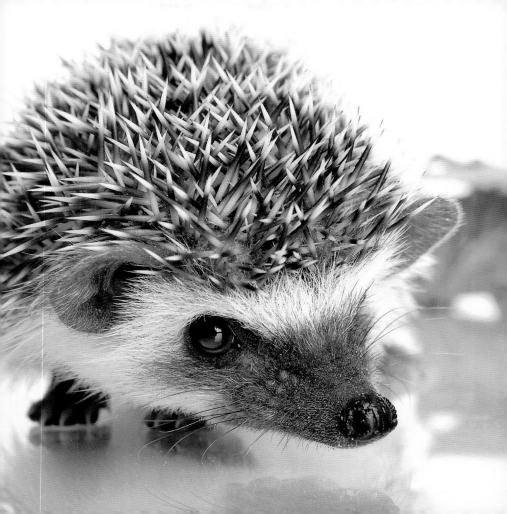

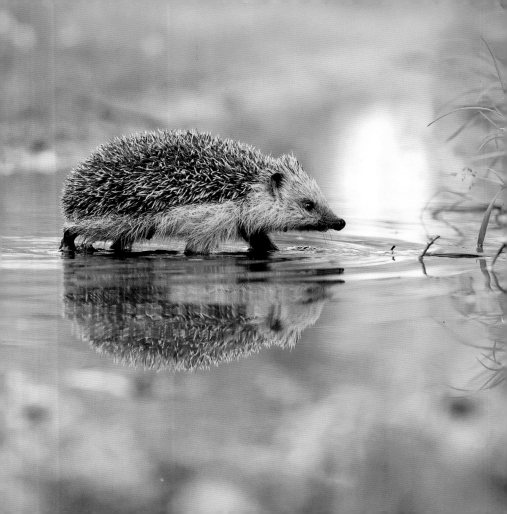

#HEDGEHOGLIFE

PEOPLE . . . WHO LOVE YOU . . . PUT THEIR ARMS AROUND YOU AND LOVE YOU WHEN YOU'RE NOT SO LOVABLE.

Deb Caletti

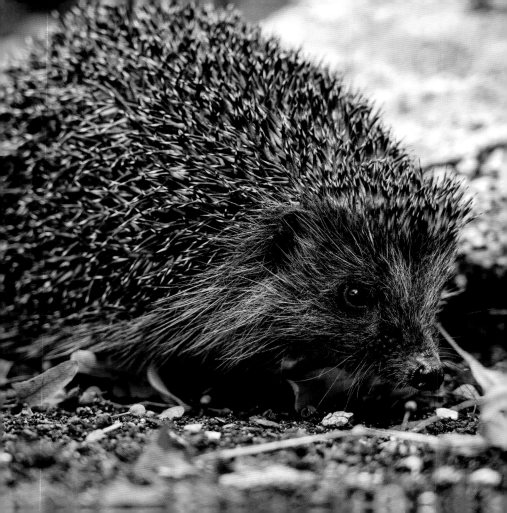

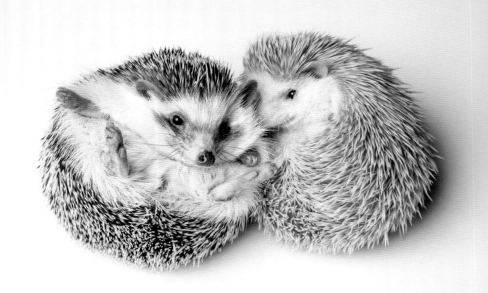

♥ I LOVE YOU ♥

THHIISSS MUCH!

A HUG SHOWS COMPASSION. A HUG
BRINGS DELIGHT. A HUG CHARMS THE
SENSES. A HUG TOUCHES THE SOUL.

Anonymous

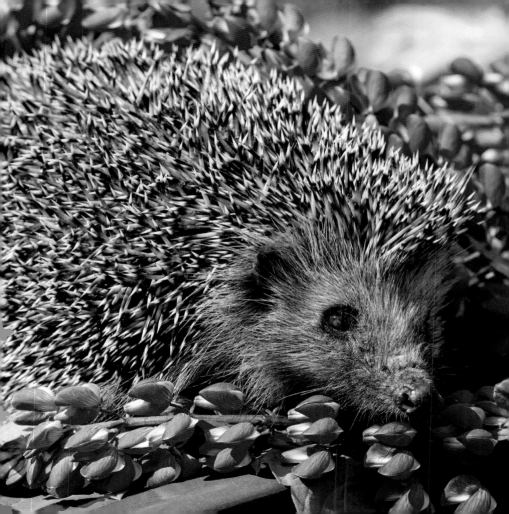

IMAGE CREDITS